100 KEYS TO GREAT OIL PAINTING

HELEN DOUGLAS-COOPER

NORTH LIGHT BOOKS

Cincinnati, Ohio

A QUARTO BOOK

Copyright © 1995
Quarto Inc.

First published in
the U.S.A. by North
Light Books, an
imprint of F & W
Publications, Inc
1507 Dana Avenue
Cincinnati, Ohio
45207;(800) 289 0963

ISBN 0-89134-693-7

This book was
designed and
produced by
Quarto Inc.
The Old Brewery
6 Blundell Street
London N7 9BH

Contents

INTRODUCTION

WHEN YOU LOOK at the work of the great painters, do you wonder how they captured the luminosity of a glowing sky, or the texture of foliage, or the sparkle of light on water? On a more practical level, do you wonder which medium to mix into your oil paints to get the effect you want, or which types of supports and surfaces you can or cannot use? Do you wonder what a glaze is and what to use it for, or how to build up the paint thickly without it cracking? There are almost as many approaches and techniques for oil painting as there are artists, and the fact that there are so few rules can make the whole process more rather than less confusing. This collection of tips is designed to answer the queries that are often raised about the materials and techniques of painting with oils, to dispel confusion about what is or is not possible, and to suggest new techniques to try. Many beginners assume that oils are more difficult to use than other types of paint such as watercolor or acrylics, but armed with a little knowledge about the materials and methods for applying paint, you may well find it easier than you imagined to get good results. Tips are included on paints and equipment, covering selection, re-use and recycling, and alternatives to purchased materials. There are different ways of mixing colors and getting color effects with oil paints, and there are also many ways to begin and build up a painting. You can start with a white or colored ground, and you can start by sketching in the composition or plunge straight in with paint.

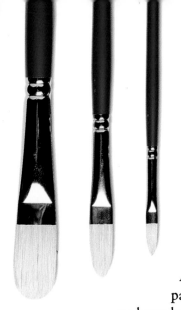

Paint can be applied into wet paint or over dry paint, it can be built up in thin, transparent layers or thick, opaque ones. It can be applied with a brush or a knife, and it can be scraped or drawn into or wiped off. And it is possible to return to a painting to do further work after a gap of weeks, or even months. One of the great advantages of oil paint is that you can keep on removing paint and reworking or painting over areas you are not happy with until they look right. And there are different ways of taking the paint off, depending on how much you want to leave behind to build on again. Oil paints can be cumbersome to take on location, but with careful selection of equipment and materials it is possible to lighten the load. There are also various strategies to help with the other problems—such as constantly changing conditions and limited time—associated with working out of doors. And then there is the problem of transporting wet paintings home again. Dramatic special effects can be created with oils by adding in materials to give the paint additional substance and texture, or by combining it with other media. Oils can also be used to produce mono-prints—the only additional equipment needed is a sheet of glass. In short, oil paint is one of the most versatile of all the painting mediums, and these tips will help you avoid the pitfalls and get maximum enjoyment out of using it.

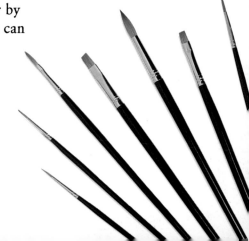

MATERIALS

When you are beginning a new medium, you may be confused by the choice of materials available to you. This section combines practical advice on paint types and mixing mediums with helpful hints. Did you know that you can recycle mineral spirits and save paint, or that you can make your own palette from a sheet of glass?

1 **PAINT QUALITY** Oil paints are available from most manufacturers in two qualities, artists' and students'. The more expensive of the two, artists' quality paints contain a higher proportion of pigment to oil, whereas students' paints are bulked out with fillers. Because they contain more pigment, artists' quality paints have more tinting power in mixtures, so you end up using less of them.

2 **TUBES OR JARS** If you get through paint quickly, or are planning to work on a very large canvas, it may be more convenient, and is probably cheaper, to buy it in large tubes or pint jars instead of standard tubes. It is particularly worth buying white in a large quantity.

3 **USING PAINT CHARTS** Colors vary in transparency and lightfastness, and this information is available on manufacturers' paint charts. The chart lists the pigment(s) used in each color, using the Color Index Generic Name for each pigment (an international index of pigments used in artist's paints), and information about the transparency and lightfastness of each tube color.

4 **LIGHTFAST-NESS** Pigments vary in their lightfastness – or resistance to fading in sunlight. Paint manufacturers provide information on the lightfastness of their colors. The number of categories varies, but they usually range from excellent to poor. Colors with an excellent rating will retain their intensity over a long period of time, whereas those with a poor rating will gradually fade and should be avoided.

5 **PIGMENTS AND SAFETY** Some pigments used in paints are poisonous if ingested over a period of time, and it is advisable to take measures to prevent paint from getting all over your hands, as it can work into the skin. Thin surgical gloves are one answer. Barrier cream is another possibility. Barrier cream prevents paint from seeping into the skin, and hands can be cleaned just by washing in soap and hot water. Avoid eating, drinking or smoking until you have cleaned all paint smudges off your hands.

MATERIALS

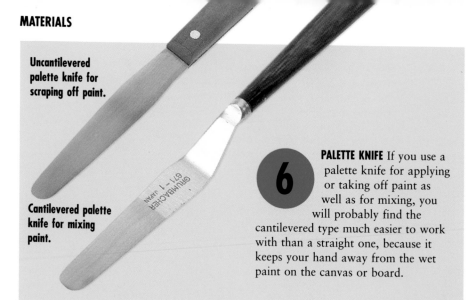

Uncantilevered palette knife for scraping off paint.

Cantilevered palette knife for mixing paint.

GRUMBACHER 871-1 JAPAN

6 **PALETTE KNIFE** If you use a palette knife for applying or taking off paint as well as for mixing, you will probably find the cantilevered type much easier to work with than a straight one, because it keeps your hand away from the wet paint on the canvas or board.

7 **MIXING MEDIUMS** Paint mediums (used to improve the flow of the paint) can be mixed easily and quickly. Recipes usually quote quantities in parts, and the easiest way to mix them is to take a jar or bottle with a tight-fitting lid and pour in the correct quantity of each ingredient in turn, marking the level on the outside of the bottle after each addition. Subsequently, as long as you add the ingredients in the same order each time, you've got a quick guide to mixing the correct quantities.

Mix ingredients in a jar with a tight-fitting lid.

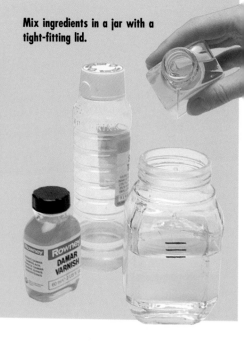

8 **PALETTE ALTERNATIVE** There are several alternatives to wooden artists' palettes that are both cheaper and available in larger sizes. A sheet of glass laid over a sheet of white, neutral or medium-toned paper is one possibility. Apply masking tape along each side of the glass so you cannot cut yourself on it. Other possibilities are formica-covered board, available from hardware stores or lumber yards.

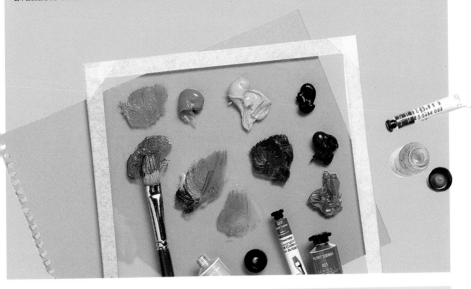

9 **MINERAL SPIRITS**
Mineral spirits that has been used for cleaning brushes needn't be poured away. Cut the top from a large plastic bottle or use a large glass jar and leave dirty spirits to stand in it until clear, although it will still be discolored. This mixture can then be poured into a clean container and stored for re-use.

SUPPORTS

You can use oil paint on a variety of supports: on stretchers, canvas (such as cotton or linen), plywood, strong cardboard, or you can try more unusual textures such as a board covered with cheesecloth and white glue. Try out different supports until you find one that suits you.

10 **ECONOMI-CAL BOARD** If you like painting on board, an economical way of buying it is in big sheets from a hardware store that has a cutting service. Large 9 × 12-foot sheets of masonite, for example, are available at an economical price, and you can have them cut up into different sizes.

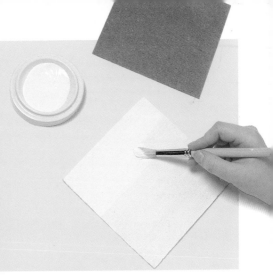

11 **PREPARING BOARD** Before priming a piece of masonite, wipe over the surface with denatured alcohol to degrease it, so that it takes the paint well. When it is dry, prime with two or three coats of acrylic primer. To add texture to the surface, you can mix some acrylic texture paste into the final coat. If you want to use an oil primer, the board will need to be sized first.

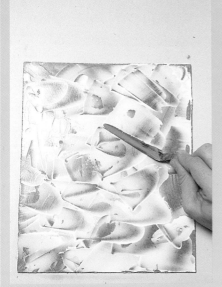

White glue is applied thinly in some areas and more thickly in others before cheesecloth is applied, which will give a varied final surface.

12 **VARIED TEXTURES** An interesting surface can be created by covering a board with cheesecloth and white craft glue. Cover the surface of the board with the glue, applied roughly with a knife or scraper; don't worry about getting it smooth. Take a piece of cheesecloth 2 inches larger than the board all around, press it down over the glue, fold the edges over to the back, and stick them down. Then apply glue unevenly over the cheesecloth, covering it in places and leaving it bare in others. When dry, the board should be primed, and a colored ground can be rubbed on lightly with a cloth. This creates a varied surface, smooth in some places, and with the weave of the cloth evident in others.

13 **CANVAS** If you like to work on canvas but want to experiment with different textures, you should consider stretching and preparing your own canvases. The standard materials are cotton duck, available in a selection of weights, and artist's linen, which gives a lively and interesting surface but is more expensive. In addition, there is braided cotton, a heavy, textured cotton with a loose weave, and fabrics such as flax and burlap, which have quite coarse surfaces and are interesting to experiment with.

Assemble the stretchers and cut the canvas to size. Staple or tack the center of each side.

14 **PRIMING** Either acrylic or oil primers can be used under oil paints. The canvas should not be sized if acrylic primer is going to be used, but should be sized (given a coat of a weak solution of rabbit-skin glue) if an oil-based primer is going to be used. Acrylic primers dry much more quickly than oil-based ones. However, sizing has the advantage that it tightens up the canvas as it dries, helping to produce a good, drum-tight surface to paint on.

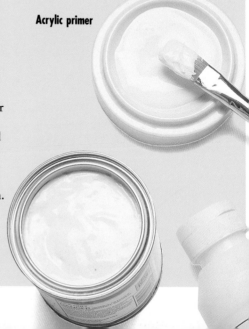

Acrylic primer

Oil-based primer; size canvas before application.

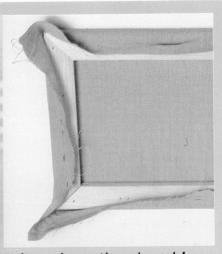

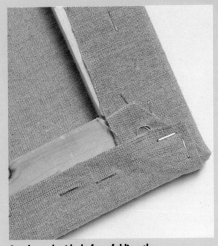

Working on alternate sides staple or tack from the center out to the corners.

Staple each side before folding the corners over.

15 **OILS ON PAPER** Oil paint can be used on paper, but the paper should be primed first. Paper absorbs oil in the paint, which makes the paint difficult to work with, and will eventually rot the paper. The answer is to prime paper with acrylic primer first. For smaller sheets of paper or cardboard for oil sketches, you could prime with acrylic paint from a tube, thinned with water, which will dry very quickly so you can start painting almost immediately.

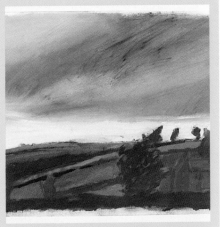

Jane Strother's "One Welsh Hillside" (detail) is painted on paper. The paint has been used thinly, and the smooth white surface of the paper gives the colors great luminosity.

16 **WEDGES** To avoid damaging a prepared canvas surface when hammering wedges into the corners, slip a piece of cardboard into each corner between the stretcher (the wooden frame supporting the canvas) and the canvas itself. This will protect the canvas if the hammer knocks against it as you hammer the wedges in, which can cause the size layer and priming to crack. Work around each corner one way, and then the other, to increase pressure on the canvas evenly.

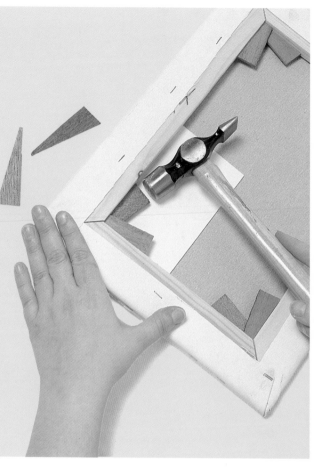

17 **STRETCHER MARKS** Irritating lines can appear near the sides of a canvas, caused by pressure against the stretcher bars behind. This can often happen if you do lots of rubbing and scraping off. The lines can be prevented by inserting strips of thin foam or bubble-wrap between the stretcher bars and the canvas to cushion the canvas, if it is pressed against the edge of the bars while you are working.

18 **DENTS IN A CANVAS** To get rid of any dents that have appeared in a canvas, take a damp, well squeezed-out rag or sponge and rub it lightly over the dent on the back of the canvas a few times. As the canvas dries, it will tighten up and the dent will disappear.

19 **RE-USING SUPPORTS** It is better not to re-use canvas or boards unless the paint already applied is not entirely dry and can be scraped off again. The new paint may not adhere properly to the surface, and the texture of the original painting may interfere with the new one. If you are re-using a support, scrape it down and wash off as much paint as possible with turpentine. When dry, re-prime with oil-based primer.

20 **ROLLING A CANVAS** Canvases shouldn't be rolled unless it is unavoidable, because it can cause cracks in the sizing and paint layers. If a canvas has to be taken off the stretchers and rolled, for storage or carrying, roll it around a cylinder with as wide a diameter as possible, and roll it with the paint surface facing out. This way, when the canvas is unrolled, any cracks will close up again.

BRUSHES AND BRUSHMARKS

To get the best results from your painting, you need to know the different brush shapes and the marks they make. This chapter covers choice and care of brushes, plus hints on achieving smooth surfaces and gradations, as well as experimenting with ways of handling your own brushes to create different effects.

21 BRUSH SHAPES You need to select the shape of brush according to the way in which you want to apply the paint. Flat-ended brushes, known as brights, are best used for covering large areas of paint, while short flats are good for dragging paint across the surface. Round-ended brushes – filberts – make tapering marks, while round brushes are good for detail.

Long flats and filberts in small sizes: use for long linear marks, applying thicker paint and details.

Round brushes: use these for small areas and details.

Long flats and filberts in medium sizes: use for applying paint over large areas.

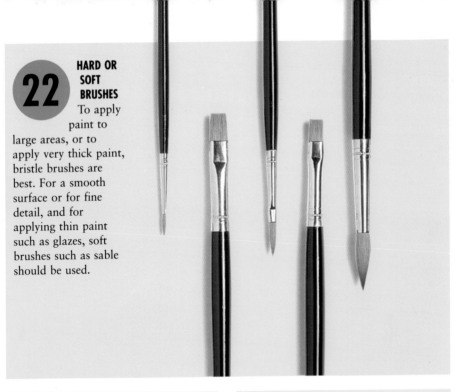

22 **HARD OR SOFT BRUSHES** To apply paint to large areas, or to apply very thick paint, bristle brushes are best. For a smooth surface or for fine detail, and for applying thin paint such as glazes, soft brushes such as sable should be used.

23 **SABLE OR SYNTHETIC** Sable brushes are the best quality soft brushes. However, cheaper alternatives are available in the form of sable/synthetic mixtures and synthetic brushes. Although these are satisfactory, they lack the springiness in the bristles that sable brushes have and do not retain their shape over time, so they may be a false economy in the long run.

24 **CLEANING BRUSHES** To get all the paint out of a brush, first rinse it in mineral spirits to get as much paint out as possible. Then draw the brush across the top of a bar of soap, with the bristles horizontal to the surface of the soap, under running water a few times. Work the soap through the bristles, drawing paint out of the ferrule, and rinse. Repeat this process until no more paint comes out.

25 **NEW BRUSHES** The bristles of new brushes are dipped in sizing to protect them, which is why they are stiff. If you try to soften them, being stiff, the bristles may crack and break off. Before using a brush for the first time, soak it in water for a while, and then rinse it with warm water and soap to get all the sizing out of the bristles.

27 **VISIBLE BRUSHMARKS** To make brushmarks that hold their shape, use a reasonably stiff bristle brush. Linseed oil mixed into the paint will also help to hold the brushmarks in shape. It is also important to have a firm support – i.e., a canvas should be tightly stretched, with some resistance in it, so that it does not give under pressure from the brush.

26 **VARIETY OF MARKS** To create a varied surface, experiment with different ways of handling your brushes. You can stab the painting with the tip of the brush for very textural marks. You can hold the brush horizontal to the paint surface and drag it across the surface for a broken application of paint, and you can apply thin paint with a scrubbing motion for a scumbled effect.

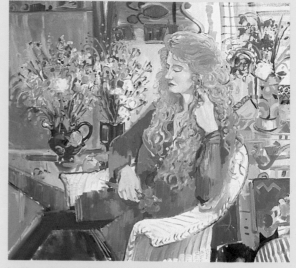

In "Anne Amongst Flowers" (detail) by Peter Graham, paint has been put on in a range of ways. Energetic vertical brushstrokes in the figure and furniture, offset with long flowing brushstrokes in the hair and distinct marks in the flowers, produce a lively image.

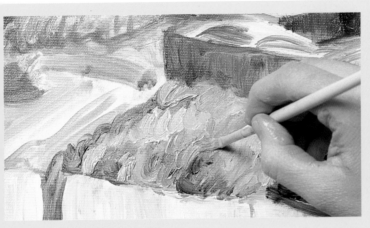

Slightly thinned
paint is applied
with a bristle
brush and holds
the brushmarks
well.

28 **A SMOOTH SURFACE** For a smooth surface with no brushmarks, mix a medium into the paint, either a commercial one, or one mixed from one part stand oil, one part damar varnish and five parts turpentine. Also, apply the paint with a soft brush such as sable.

To get a smooth surface
use a soft brush and long
strokes.

21

BRUSHES AND BRUSHMARKS

29 **A SMOOTH GRADATION** To get an absolutely smooth, barely perceptible gradation from one tone or color to another, prepare a color mixture for each. Apply the colors separately, the darkest one first and the lighter one next to it, with a clean brush. Blend initially with a bristle brush, and then switch to a fan brush, using short strokes and working across the edge between the two areas of paint.

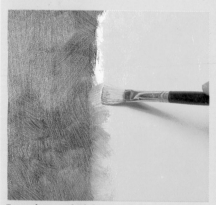

Two colors are laid down and then pulled into each other.

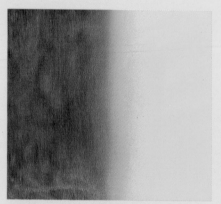

The colors have been blended together until a smooth gradation is achieved.

30 **ROUGH BLENDING** Apply two tones or colors next to each other, and knit them together with short zigzag strokes to create a broken edge.

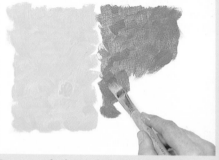

Two areas of color are laid next to each other.

31 **LOOSENING UP** If your work has become very tight, or if you tend to be distracted by detail, try using very large brushes and other implements that force you to apply the paint in large, simplified blocks of color. Household painting brushes, signwriters' brushes and paint scrapers are all good implements to try. Also, try using the paint very thinly in the early stages as this will make it that much easier to apply quickly.

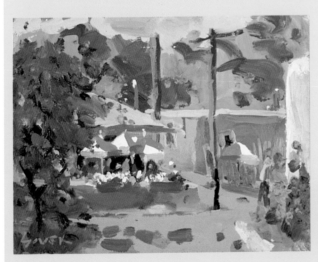

In Charles Sovek's "Canyon Road Café " very loose, broad marks are used to suggest different elements in the subject.

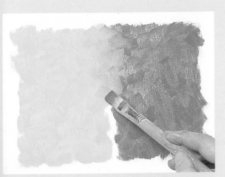

The two colors are pulled into each other with short, zigzag strokes.

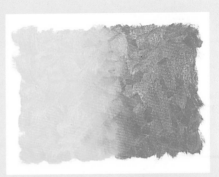

The transition from one color to another is gradual but broken.

COLOR

For fresh, lively colors, it is easier to begin with a small selection of individual tubes, rather than painting sets. In this way, you learn to identify the colors you see and to mix them accurately. This section explains which colors you need, and gives tips on mixing colors and on methods of harmonizing colors.

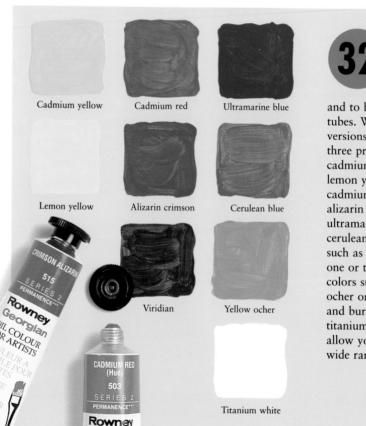

Cadmium yellow

Cadmium red

Ultramarine blue

Lemon yellow

Alizarin crimson

Cerulean blue

Viridian

Yellow ocher

Titanium white

CRIMSON ALIZARIN
515
SERIES 2
PERMANENCE'''
Rowney
Georgian
OIL COLOUR
FOR ARTISTS
COULEUR A
L'HUILE POUR
ARTISTES
FARBE
STLER
R AL
ARA

CADMIUM RED
(Hue)
503
SERIES 2
PERMANENCE'''
Rowney
Georgian
OIL COLOUR
FOR ARTISTS

32 **CHOICE OF COLORS** It is best to avoid sets of paints and to buy individual tubes. Warm and cool versions of each of the three primaries – cadmium yellow and lemon yellow, cadmium red and alizarin crimson, ultramarine blue and cerulean blue – a green such as viridian, and one or two earth colors such as yellow ocher or raw sienna, and burnt sienna, plus titanium white, will allow you to mix a wide range of colors.

33 **LAYING OUT COLORS** Colors can be laid out on a palette in various ways – light to dark, warm to cool, or in the order of the spectrum. The order in which you lay them out is less important than always laying them out in the same order, because then you'll know approximately where each color is without having to look for it. This is a particular advantage when you're on location and mixing colors quickly. It also reduces the chances of picking up the wrong colors on the brush by mistake.

34 **CLEANER COLORS** If your colors look muddy on the canvas, it could be that you've mixed too many colors together. For fresh, lively colors, mix the minimum number – preferably two or three. Unwanted colors can creep into a mix from a dirty brush, so keep cleaning your brushes after each application, and have separate jars of mineral spirits for cleaning brushes used for different colors.

Muddy

Cadmium red
Cobalt blue
Paynes gray
Yellow ocher

Chrome yellow
Yellow ocher
Cerulean blue
Cobalt blue

Cadmium red
Alizarin crimson
Chrome orange
Cobalt blue

Bright

Cadmium red
Cobalt blue

Chrome yellow
Cerulean blue

Cadmium red
Chrome orange

35 **MIXING COLORS** To save wear on your brushes, mix paint on the palette with a palette knife, or reserve some old brushes just for this purpose. A knife is also quicker than a brush for mixing large quantities. Mix the darker color into the lighter one, a small amount at a time, until you have the shade and color that you want. Mix up more of a color than you think you'll need so that you don't have to try to match the mix again later.

36 **BROKEN COLOR** Very vibrant color effects can be achieved through broken color – applying a layer of color so that the color underneath shows through in places, with the two mixing in the viewer's eye to create a third color – through techniques such as scumbling and pointillism. Complementary colors used in this way will create an effect of shimmering light.

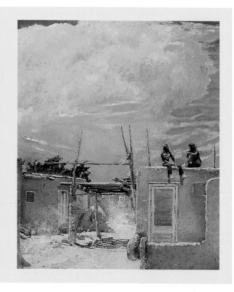

In "Before the Storm" by Nelda Pieper, the light in the sky is created by dragging bluish sky and cloud colors over a burnt sienna background.

37 **DARKS WITHOUT BLACK** Mix darks rather than using black: ultramarine and burnt sienna, or alizarin and viridian make good vibrant darks, and ultramarine and cadmium red dark produces a color that is almost black but is capable of subtle modulations of warmth and coolness.

Ultramarine + cadmium red

Alizarin + viridian

Ultramarine + burnt sienna

38 **SUBTLE COLOR MIXES** To get more subtle color mixes than those produced by mixing colors on the palette, you could try glazing transparent layers or scumbling broken layers of color one over another. The colors will be the same, but they will be very subtle and luminous.

Red + green

Yellow + violet

Red + dark red

Yellow + yellow ocher

Red + black

Yellow + black

39 **DARKENING TONES** Black added to colors to darken them can produce dull, dirty-looking results. Instead, try mixing in a darker version of the same or a similar color, or mix in a little of the color's complementary color for a darker, but slightly grayed version. The complementary pairs of colors are red and green, blue and orange, and violet and yellow.

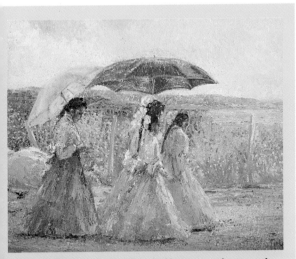
In "Anna's Daughters" (detail) by Nelda Pieper, color is caught by scumbling and dragging one color over another.

40 **A UNIFIED EFFECT** To harmonize the colors used across a painting, apply a layer of color to the white ground – known as a toned ground – before starting the painting. If glazing and scumbling techniques are used to allow the ground color to show through in places, it will have a unifying effect on the painting.

APPLYING PAINT

A pure white canvas can be inhibiting, whereas if you stain or color the surface, this gives you a good basis to work on. Build up your confidence by experimenting with ways of creating light with glazes, achieving lost-and-found edges, or adding in highlights, following the useful advice in this chapter.

41 **TO PREVENT CRACKING** Cracking occurs when a top layer of paint dries more quickly than those underneath. To prevent this from happening, you need to follow the principle of "fat over lean." This means that each successive layer of paint should have more oil mixed into it than the previous layer. Other ways to prevent cracking are to let one layer dry before applying another, and to avoid the slower-drying colors, such as alizarin crimson, in the early stages of a painting.

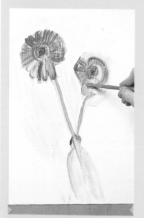 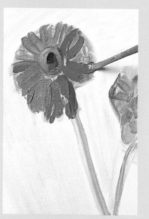 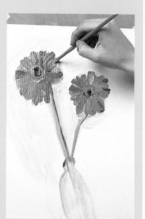

Broad areas of color are blocked in using paint thinned down with turpentine.

A layer of thicker paint, mixed with a little linseed oil, is applied over the top.

Layers of paint continue to be built up to give texture and definition.

42 **STAINING A GROUND** To stain a white ground with transparent color, choose or mix a color that is darker than the final result that you want, and thin it with turpentine until it is quite runny. Apply it all over the surface with a wide brush, and then rub back with a cloth until you have the tone and degree of transparency that you want. Alternatively, you can rub the paint on with a rag.

43 **EASY START** If you find a pure white canvas inhibiting to work on, try applying a colored ground – a layer of color put on over the primer. Transparent colors such as yellow ocher, raw sienna, burnt sienna or a neutral gray are good choices. Then begin the painting either by wiping out the light areas with a rag, or by putting in the dark areas, either of which will give you a good basis to build on.

Paint thinned with turpentine is applied with loose brushmarks.

A cloth is used to take off some of the paint to give a very light, transparent layer of color to work on.

Preliminary charcoal sketch.

Main shapes filled in.

Details added.

44 PRELIMINARY DRAWING

The main shapes of the composition can be drawn in with pencil, charcoal or paint. If charcoal is used, either brush away the excess or spray it with fixative if you don't want it to be picked up and blended into the first layer of color.

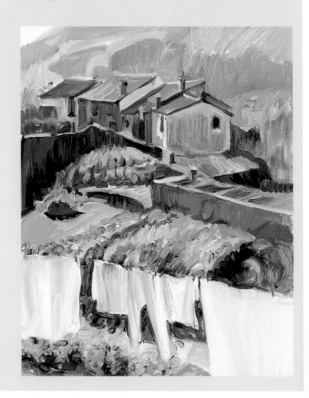

45 **UNDERPAINTING** If you have trouble making tonal sense of colors, a monochrome underpainting provides a good guide for a painting. Working in one color, or a gray mixed from two colors, make a tonal painting of the subject in thin paint. The lighter tones can be created either by thinning the paint right down or by mixing in a little white. Let the underpainting dry and then apply colors over the top.

46 **WET INTO WET** To keep the colors clean and vibrant when working into wet paint, work with a limited palette and have a plentiful supply of brushes. Load the brush with plenty of paint, and make a quick stroke holding the brush as nearly horizontal to the painting surface as you can.

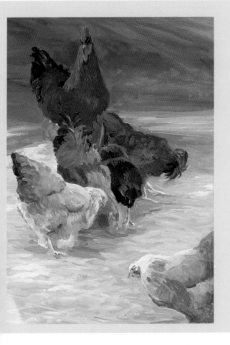

In "Pecking Order" by Denise Burns, individual brushstrokes of strong color are worked into wet paint with decisive marks to create an image that has clean and vibrant color.

47 GLAZING

To get a smooth, transparent layer of color, for surfaces such as water or glass, or to create interesting darks, mix the paint with a glaze medium, either one you have mixed yourself or a commercial one – not with turpentine, which will take off the previous layer of paint – and apply it with a soft brush.

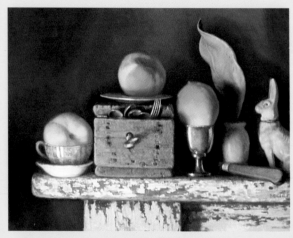

In "March Peaches and Hare" by Deborah Deichler, the layers of thin paint give depth to the shadow areas.

48 LIGHT WITH GLAZES

To retain a sense of light, apply glazes over light or neutral colors because they reflect light best and because the color will darken with each layer of color added.

Depth of tone is achieved by applying layers of thin paint to model the face.

49 **QUICK GLAZING** Some commercial glazing mediums increase the flow and transparency of the paint, although some also make the paint very shiny, so you will need to experiment with them to find out what you like. They may also speed up the drying time, which makes it possible to continue to the next stage on the following day.

50 **SPEEDING UP DRYING** You can slightly speed up the time each layer of paint takes to dry by mixing in either a small amount of one of the commercial oil-painting mediums that has this effect, or by mixing a little damar varnish into linseed oil and mixing this into the paint. It isn't a good idea to speed up the drying time too much, as the painting will probably either crack or develop an unpleasant skin.

51 **HIGHLIGHTS** To look convincing, highlights shouldn't be painted with pure white. Even the brightest highlights contain a hint of color, so mix in a touch of warmth or coolness, or a more distinct color if that is appropriate. Apply highlights at the very end of the painting.

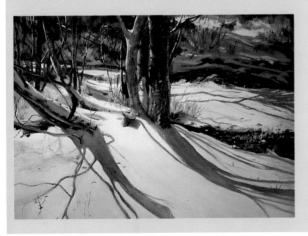

Even the lightest areas in a scene contain a hint of warm or cool color, as illustrated in Martha Saudek's "Sierra November."

52

SHARP EDGES When you want to achieve sharp edges, you have two options. One is to work wet over dry. If you are working wet into wet, lay one color down with a stroke that runs in the same direction as the edge, and then lay the second color beside it, manipulating the brush so that the two colors butt up against each other.

Lay the second color so that it just butts up against the first color.

53

BROKEN EDGES For edges where you want a broken, lost-and-found effect, such as for clouds, shadows, or the horizon, work wet into wet and slightly mix the two tones or colors by pulling one into the other here and there on the canvas. Another way is to scumble paint along the edge.

Areas of color are laid down next to each other.

Colors are pulled into each other around the edges.

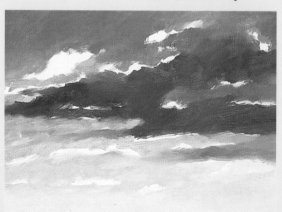

A mixture of hard, soft and broken edges create depth.

ADDITIONAL TECHNIQUES

As your painting progresses, you may want to try some of the interesting ideas and more advanced methods featured in this chapter. Knife painting, drawing with paint, and the techniques of impasto and pointillism are some of the ways of adding character to your paintings.

54 **DRAWING WITH PAINT** Details such as foreground grasses in a landscape, hair or fur textures, can be drawn in. Thin the paint with a glazing medium, not turpentine, and using a very fine, soft brush such as a sable watercolor brush, put them in with distinct, separate strokes, reloading the brush each time. This technique can also be used to put in larger details and can be used in a looser, freer way.

The ripples in the water are drawn in using thin paint and a small brush.

55 KNIFE PAINTING

For a highly reflective paint surface and bright colors using opaque paint, the paint can be applied with a knife. To get the smooth surface needed to reflect the maximum amount of light, apply the paint boldly and lift the knife off cleanly at the end of the stroke. Resist the temptation to go over the stroke once it is made, as this will disturb the paint surface and kill the effect.

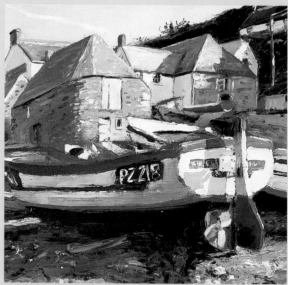

In "Early Morning in Cadgewith" (detail) Jeremy Sanders has applied the paint over a colored ground with a palette knife and a credit card cut in half, using them flat and on their edges to create a variety of different types of marks and textural effects.

56 SCUMBLING

Scumbling involves applying paint over a previous layer in a way that allows the color underneath to show through. To get a broken application of paint, use an almost dry brush and thick paint. Keeping the brush horizontal to the surface, pull it across quickly and lightly, and don't go over the application again. It works best on a textured surface, as only the raised points in the weave pick up paint from the brush.

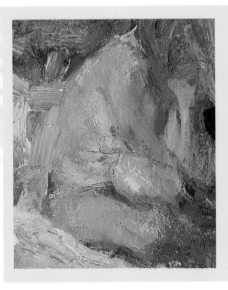

57 **IMPASTO** If you want an application of thick paint, it is best to build up the paint in layers, letting each layer dry before applying the next, in order to avoid cracking. Apply the paint with short strokes, using a brush or a knife.

In "Bedroom Study" by Arthur Maderson, the image has been built up with thick, rich applications of paint, giving the paint itself a three-dimensional quality.

58 **SGRAFFITO** An alternative way to indicate intricate details, such as details on windows, rain, or fabric such as lace, rather than painting them in, is to use the technique called sgraffito – scraping through the paint to reveal the color underneath. With wet paint, just draw into the paint with a knife or the end of a paintbrush. With dry paint, more vigorous drawing and scraping will be needed.

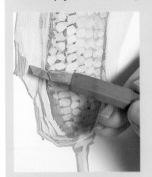

Very fine details can be added with this technique.

The veins of the leaf are drawn into the paint.

59 POINTIL-LISM If you have tried the pointillist technique and the colors don't seem to be mixing, it could be because the colors you are using vary too much in shade. To work effectively, the colors used should be the same shade. Use dryish paint, and apply it in short strokes, making sure that the brushstrokes don't blend together.

60 CREATING TEXTURE One way to suggest texture is to press crumpled or textured paper to the paint surface and lift it off again, leaving an imprint of the texture in the paint – a technique known as frottage. Experiment with different textures to see what effects they create.

61 STRONG CONTRAST Subjects with a strong contrast between light and dark can be captured by applying a dark-colored ground over the primed canvas and using light-toned or brightly colored opaque paint over the top.

62 VARNISHING In order to get a smooth finish when varnishing, and to minimize reflections on a varnished painting, place the painting flat on a firm, level surface and apply the varnish in brushstrokes that run vertical to the image. Use a varnishing brush, which will pick up plenty of varnish, as each stroke needs to be made in one continuous sweep from the top to the bottom edge of the painting.

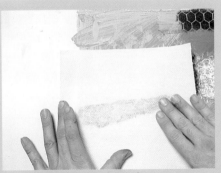 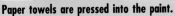

Paper towels are pressed into the paint.

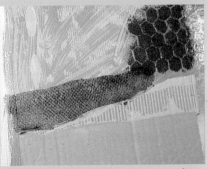

The texture is transferred to the paint surface.

63 **REWORK A PAINTING** With oils, it is possible to return to a painting and do more work after a gap of weeks, or even months. However, the new color will look much brighter than the dry paint. In order to judge one against the other, you can apply retouching varnish thinly to the dry paint, which will bring up the colors again. When the varnish is dry, it can be painted over if desired.

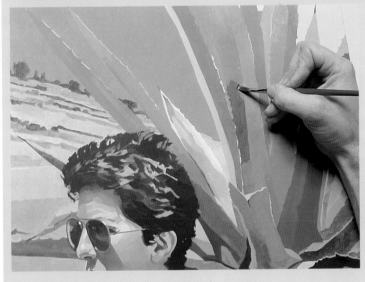

Fresh paint added to a painting that has been allowed to dry looks much brighter than the previous application.

MODIFICATIONS AND CHANGES

There are a number of ways to correct your paintings, even when you think it is too late to do anything. For example, dull, flat sections can be enlivened with scumbling, or knocking back over-bright color can be done with your fingers. These are just two of the helpful hints described in this section.

64 **LIGHTENING A COLOR** To lighten a color on the canvas, you don't need to work white into it, or to apply a lighter shade over the top. As long as the paint isn't dry, try rubbing or scraping off some of the paint so that more light is reflected by the white ground. Another possibility may be to darken other colors nearby – as long as this won't upset the overall tonal balance. The original color will appear lighter against the darkened ones.

Rubbing back lightens the color.

Cadmium red + phthalo green

Dioxazine purple + lemon yellow

65 **DARKENING A COLOR** To darken a color that has already been applied to the canvas, let it dry, and then glaze its complementary color over the top.

66

MAKING CHANGES When you are working wet into wet, this can lead to a buildup of paint that becomes difficult to work with, especially if you want to make changes; and if you apply fresh paint to make a change or correction over wet paint, the colors will probably become overmixed. It is best to scrape off excess paint with a knife or remove it with a rag.

Scrape off as much paint as possible before making changes to the painting.

67

OVERWORKED AREAS To unclog an overworked area without removing all the paint, leaving a basic layer of color to build on again and the texture of the support still in evidence, you can use the technique known as tonking. Use a smooth, absorbent paper such as newsprint; press it against the paint surface; and remove it. Repeat with a fresh piece of paper until you have removed as much paint as you wish.

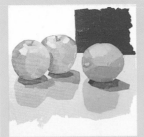

The background is too heavy.

Newspaper is applied to the overworked area.

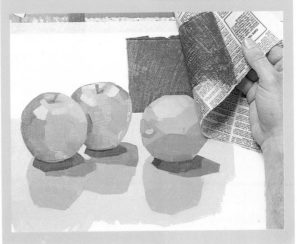

68 **ENLIVENING DULLNESS** If there are dull, flat areas in a painting, try scumbling another color, such as the complementary color, over the top. Adjusting other colors nearby or introducing tiny touches of a bright color may also do the trick.

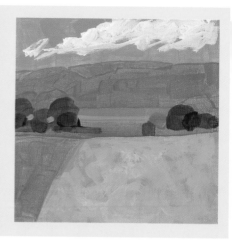

Bright yellow scumbled over the foreground field and added into the trees brightens up these areas and introduces a feeling of light into the scene.

69 **SUNKEN PAINT** Sometimes areas of color appear to "sink." This can be cured either by "oiling out" – rubbing a little linseed oil sparingly over the area in question with a soft cloth and leaving it for 24 hours, or by giving it a thin coat of retouching varnish using a soft brush and leaving it to dry, which takes up to about 15 minutes.

70 **OVER-BRIGHT AREAS** Areas of color that are too strong can be knocked back by blending the edges with the colors next to it, or by knocking it back with a finger. Or, the color can be modified by scumbling or glazing another color over it.

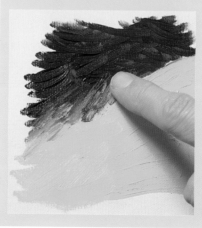

The yellow is toned down by blending it around the edges with the color next to it.

SPECIAL EFFECTS

Oil paints can be used to achieve a number of exciting and unpredictable results, for example, by mixing media such as using oil or soft pastels over dry oil paint, or experimenting with fabric or paper collage. Monoprinting, also featured in this chapter, is another interesting method to add to your range of painting skills.

71 **ADDING TEXTURE** It is not a good idea to apply paint too thickly because you run the risk of cracking. If you want a very heavy impasto effect, it is better to add something into the paint to thicken it. It can then be applied to the support and sculpted with a palette knife. A grainy effect can be achieved by mixing in sand, while a slightly granular effect is provided by sawdust.

Sand mixed into the paint makes it thick and textured.

Sawdust produces a very rough textured surface.

72 **COLLAGE** To collage fabric, paper or objects to an oil painting, it is best to attach them directly to the support with glue before you apply any paint. If you are gluing them to the support, it is best to prime the support with acrylic primer and use white glue to attach them, which can then be painted over with oil paint. A board will support the weight of collaged materials much better than canvas.

73 **IMPRINTING** If you can't get the texture you want in a thick paint surface with knives or brushes, try making marks and patterns in the paint with other implements, such as a fork, a slotted spoon or the end of a canister, drawing them across the surface or pressing them into the paint, depending on the type of pattern you need. Experiment with this technique before trying it in a painting.

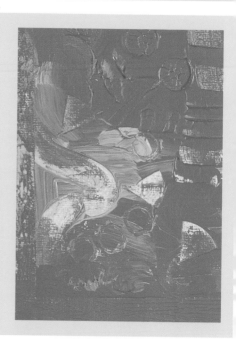

Patterns have been pushed into thick paint: the round marks were made with a film canister, the triangular ones by twisting the end of a ruler, and the rough areas by dabbing with a crumpled facial tissue.

74 **MIXED MEDIA** Interesting textural effects can be created by using oil or soft pastels over dry oil paint. They can also be used to add in or redefine small details and to emphasize the separation between one area and another.

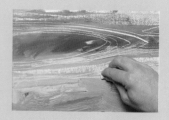

75 MONO-PRINTING

To produce exciting and unpredictable results with oil paints, try making monoprints. These are created by using a sheet of glass and thinly applied paint. Either paint the image directly onto the glass, or spread the glass evenly with paint and create the image by removing paint – wiping it off with a rag and drawing into it with different instruments. Then place a sheet of drawing paper over the top, press gently, and peel the paper off again. The print can be worked into further with more paint or with oil pastels.

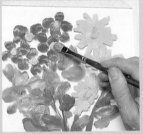

Oil paint is applied to a sheet of glass.

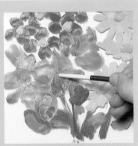

Texture is added by drawing into the paint.

Paper is laid over the top.

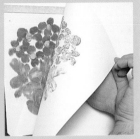

The paper is peeled away.

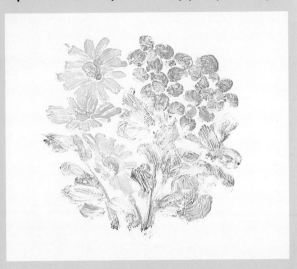

A very delicate and textural print is produced from the original. Only one print can be made from each painting on glass.

ON LOCATION

It is not easy to decide what to take when you are setting off to paint in a new place. To make the most of working outdoors, you should reduce your equipment to a minimum and organize it so that it is as light and easy to carry as possible.

76 **PAINT BOXES** A convenient type of paint box for working on location is a ready-made box which combines palette and paint box in one and holds boards in the lid. These boxes are available in a choice of sizes. The smaller sizes can be held in one hand, while leaving the other free to paint, or they can be rested on a wall or on the knees if you are sitting.

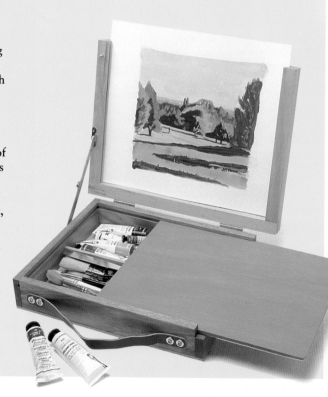

77 LIMITED PALETTE

When you are working fast or in difficult conditions, it helps to limit the number of colors that you use. You will need one each of the primary colors in some form: a yellow, a red or reddish orange, and a blue, plus white. Lemon yellow, burnt sienna and cobalt blue give a selection of fresh colors; yellow ocher, cadmium red and cerulean blue give a choice of bright or subtle colors.

Very limited palettes can provide a good choice of colors to work with. They can be mixed to produce a range of interesting grays and browns, darkened through the mixing of complementaries, and made lighter and more opaque with the addition of white.

Lemon yellow Burnt sienna Cobalt blue

Lemon yellow

Burnt sienna

Cobalt blue

Mixed with 50% white

Pure mixes

Cerulean blue Cadmium red Yellow ocher

Yellow ocher

Cadmium red

Cerulean blue

Mixed with 50% white

Pure mixes

78 **A STEADY EASEL** Even quite a mild breeze can catch a large board or canvas on a sketching easel and blow it over. To prevent this from happening, suspend a bag – a plastic shopping bag will do well – filled with something heavy such as stones that you can collect on the spot, from the center of the easel to weigh it down.

79 **TWO PALETTES** Two small palettes are easier to manage than one large one on outdoor painting trips, if you need plenty of space for mixing colors. A small palette is easier to hold in difficult weather conditions, and smaller sizes are easier to pack away for carrying.

80 **LIMITED TIME** When you have a limited time in which to complete a painting, the best approach is to break down the subject into simple overall shapes and block these in with thinned-down paint. At this stage don't mix more than two colors together and don't add white. Control the tones through the thinness of the paint, and wipe back any areas that are too dark. This will give you a clear foundation on which to build the painting.

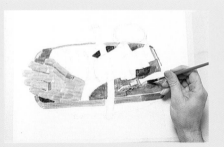

The subject is reduced to a series of simple shapes.

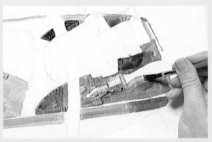

The composition is blocked in simple, flat areas of color using thinned-down paint.

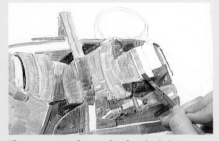

The paint is used very thin for the lightest tones of the painting.

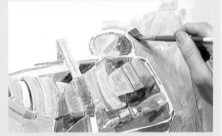

The background is put in with a suggestion of light and shadow.

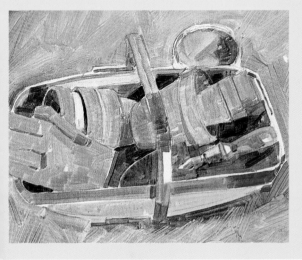

The painting has been kept simple and controlled to provide a good guide for building up subsequent layers of thicker paint and more varied tones and colors.

81 **SHORT-TERM SUBJECTS** Some subjects, such as market scenes, are only there for a short time. To retain the immediacy of working directly from life, make a pencil drawing of the scene on the spot on stretched watercolor paper, recording all the information you want to include in the painting. Additional color notes will be useful. When you get home, give the paper a coat of shellac varnish, which will seal the surface without concealing the drawing. When the shellac is dry, apply paint, working fast over the drawing to complete it in one session.

Use a varnishing brush to give the drawing a coat of shellac varnish to seal the surface.

82 **QUICK DRYING TIME** Quick-drying alkyd gel medium will speed up the drying time of the paint. It is available in tubes and can be squeezed out on the palette. Add a little to the paint that you mix for blocking in the composition to prevent subsequent layers picking up color from the first layer.

83

CARRYING WET CANVAS To carry a wet canvas or board, you will need a second canvas or board of roughly the same size, plus four small pieces of cork about ¼ inch thick, and some masking tape. Lay the painting flat and place a piece of cork in each corner. Place the second board or canvas on top, and tape the corners together. The painted surfaces are held apart, but face in and so protect each other. If the corks leave a mark, the corners can be touched up again at home.

Using a brush to mix alkyd gel medium.

SUBJECTS

As experience will show you, there is no correct way to paint a particular subject – a still life and a portrait painted by the same artist will not vary much in style or technique. However, there are still a few subject-related problems, and this chapter contains some useful ideas for solving them. With all subjects, it is best to concentrate on portraying them in terms of light and dark, rather than including too much detail.

SKY HOLES To put in "sky holes" seen through foliage, put in the foliage first and then add in patches of sky over the top, roughly blending them into the foliage around the edges so that they are not too stark.

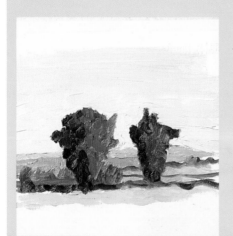

Trees are put in as solid areas of foliage and modeled with light and dark tones.

Sky holes are added into the trees to create a natural effect.

85

KEEP IT SIMPLE Avoid including too much detail, and observe correct color relationships. The temptation is to look at colors individually, which can lead to their being too bright. Put down as many of the main colors as possible quickly at the blocking-in stage so that you can assess all the colors in the painting in relation to each other.

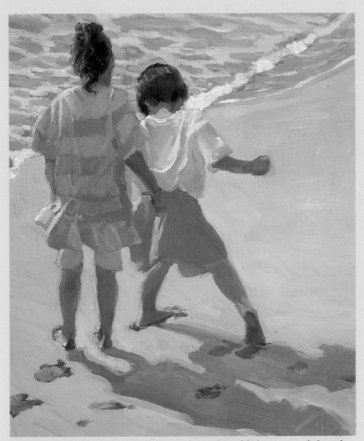

In "Footprints" (detail) by Denise Burns, the quality of light is created through the contrast between yellow highlights and violet shadows. Where there are extreme color or tonal contrasts, establish them early and then work between them.

86 **FLAT FIELDS** In order to make a field extend forward from a hedge, work a line of darker tone along the bottom of the hedge. Then put in a light line along the edge of the field where it meets the hedge and blend it back if necessary so that it isn't obvious.

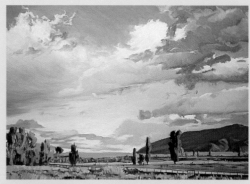

In "Evening Skies" by Martha Saudek the light across the distant fields makes the land recede back toward the horizon.

87 **SKY AND LAND** The sky shouldn't be painted with smooth, thin paint just because that seems to express insubstantial air. It should be painted in the same style as the land or sea in order to unify the two areas. Keep the brushstrokes in scale with the scene as a whole.

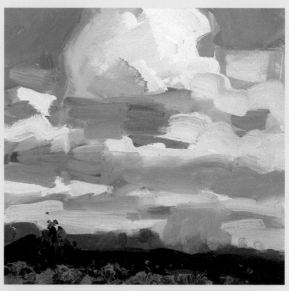

In Charles Sovek's "Clouds over Sante Fe" land and sky are unified.

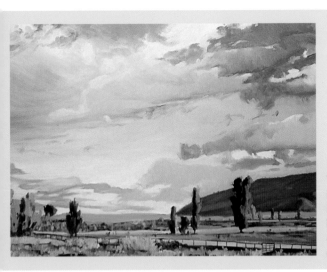

The detail shows the paint is kept smooth for the land itself, and the plants in the foreground emphasize the feeling of depth in the scene.

In this detail from "From the Ridgeway" by Brian Bennet, thick paint gives the clouds substance.

88 SUBSTANTIAL CLOUDS

To create clouds with form and volume, remember that the lightest area is not at the edges unless they are backlit. The upper surfaces will be reflecting sky color, while the underside will reflect earth tones. The lightest area will be within the body of the cloud, and it should be painted quite thickly.

89 **LIGHT ON WATER** To capture light on water, either put in the darker shades first and add highlights over the top; or apply patches of a light color first, and when it's dry, drag darker colors over the top, letting the light color show through.

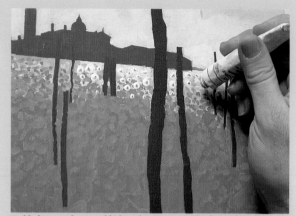

Highlights are being added with paint straight from the tube.

90 **FOCUS ON FOLIAGE** If you are including a clump of branches or foliage in the foreground, concentrate on portraying it in terms of areas of light and dark, instead of trying to paint individual branches or leaves.

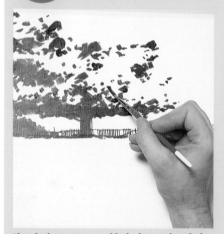

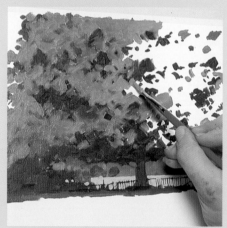

The shadow areas are blocked in with a dark shade of green.

A medium green is worked over the rest of the foliage area.

91 **PORTRAITS** Keep the paint thin, and remember that removing paint is as important as putting it on. Paint can be removed with a rag, a clean brush or a knife. Remove it gradually until you have worked back to an effect you like.

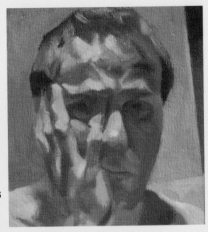

Features are easier to model if you keep the paint thin, as shown in "Self Portrait" by Ashley Hold.

Multidirectional brushstrokes suggest foliage, but no attempt is made to paint leaves.

A light green is added. The combination of shades creates a feeling of depth.

92

SKIN COLORS Mix the colors you need, rather than buying flesh colors, which will be flat and uninteresting. Take three or four colors – such as alizarin crimson, yellow ocher and white, or burnt umber, alizarin, cobalt blue and white – and use them to mix a base color that you can warm and cool, lighten and darken as needed.

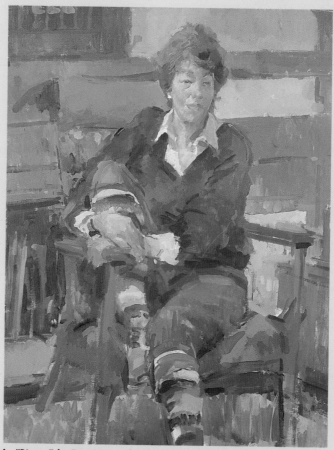

In "Dianna" by Tom Coates, the skin and background colors are mixed from the same palette of earth yellows and reds, blue and white.

93 **MOVING FIGURES** Wet into wet is the best technique for portraying figures in action because it is easy to blur areas of the body – especially legs and feet – to suggest motion, and no part will end up too sharply defined.

The head and shoulders are in sharp focus, but the arms and legs are painted as a blur of activity and movement.

94 **GROUPS** Groups of figures, including just two together, should be blocked in initially as one overall shape. Then indicate where the light is falling on each figure to distinguish it from the others and from the surroundings.

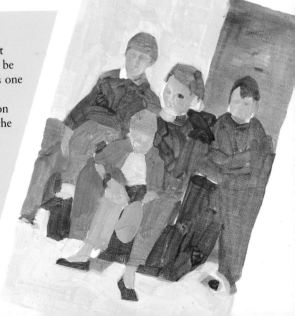

SUBJECTS

95 **CHILDREN** Young subjects will find it difficult to keep still for any length of time while you paint them. One way to speed up the process is to make a monochromatic underpainting in acrylics, which will dry quickly, and you can add color over the top with oil paint.

The recessed parts of the folds, that is, the dark shadow areas, are put in first in a dark tone of the fabric color.

96 **CONVINCING FOLDS** To paint folds in cloth, work in about five shades, exaggerating the warm and cool darker tones so that the highlights stand out. Also, work dark to light, keeping the paint thin to start with, and applying the highlights last in thicker paint.

The middle tones are added next. They are carefully blended with the darks to suggest a continuous surface.

The lightest tones are added. A light tone against a dark gives a sharp change in plane, whereas a gradual transition describes a curving surface.

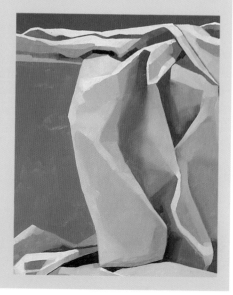

60

The background is blocked in, establishing the space and tonal range.

97

BACKGROUNDS The background is as important as the subject and should be seen and painted as an integral part of the composition. Build it up using the same kind of marks and techniques as for the main subject, and keep moving to and fro between the subject and the background so that you can keep judging the colors and tones of one against the other.

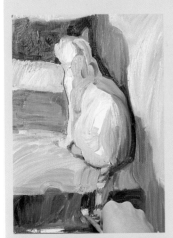

Background tones are darkened in places, giving definition to the cat.

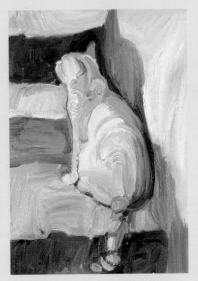

Subject and background are painted in the same style, giving the painting a unified feel.

98 **PAINTING GLASS** To capture glass, first paint the background and anything inside the glass such as flowers and stems, observing the distortions caused by glass or water. Then indicate the edges of the object in terms of the light and dark tones that you see, and put in simplified reflections and highlights.

99 **FLOWERS** To prevent a painting from becoming fussy and overworked, plan the composition carefully to begin with, and then try to work using bold brushstrokes to describe the shape and direction of the petals and leaves, and leave them alone once made. If you are not happy with any area, scrape off the paint and try again.

Anything that can be seen through the glass, such as the flower stems and glimpses of the background, are painted in.

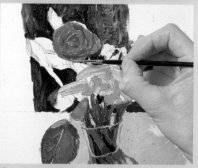

The rose is painted by following the circular arrangement of the leaves, leaving the paint thin in the lit areas.

The edges of the vase are indicated through changes of tone between the glass and the background.

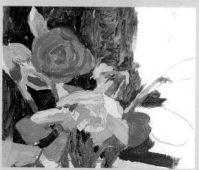

The daffodil buds are put in with short, directional marks that establish their roundness and solidity.

100 **PAINTING METAL** Metallic surfaces reflect their surroundings, but the colors will be duller than the things they are reflecting, except in highlights. You can use the reflections to describe the shape of the object itself.

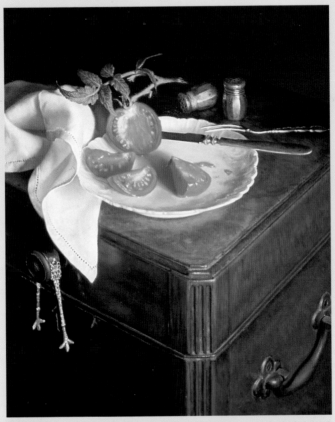

The shape and reflective quality of the metallic objects are described through the way they are reflecting light and colors from the surrounding objects, as demonstrated in this work – "Tomato with Salt and Pepper" – by Deborah Deichler.

CREDITS

Quarto would like to thank Jeremy Galton, Ian Sidaway and Karen Rainey for
demonstrating the art techniques.

Quarto would also like to thank Daler-Rowney who supplied the artist's materials;
and Peter Russell of P.R. Art, Stevenage, Herts, who supplied the pochade box.

Art editor Clare Baggaley
Designer Tanya Devonshire-Jones
Photographers Laura Wickenden
Text editor Jane Donovan
Senior editor Kate Kirby
Picture researcher Jo Carlill
Picture manager Giulia Hetherington
Editorial director Mark Dartford
Art director Moira Clinch

Typeset by Genesis Typesetting, Rochester
Manufactured in Hong Kong by Regent Publishing Services Ltd.
Printed in China by Leefung-Asco Printers Ltd.

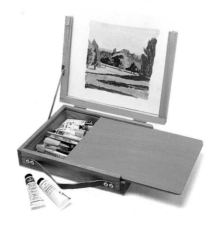